This library edition published in 2011 by Walter Foster Publishing, Inc.
Walter Foster Library
Distributed by Black Rabbit Books
P.O. Box 3263 Mankato, Minnesota 56002

Printed in China, Shanghai Offset Printing Products Limited, Shenzhen.

First Library Edition

Library of Congress Cataloging-in-Publication Data

Sorg, Eileen (Eileen F.)
 Colored pencil / by Eileen Sorg. -- 1st library ed.
 p. cm. -- (Drawing made easy)
 ISBN 978-1-936309-15-3 (hardcover)
 1. Colored pencil drawing--Technique. I. Title.
 NC892.S67 2011
 741.2'4--dc22

 2010008420

022010
0P1815

9 8 7 6 5 4 3 2 1

COLORED PENCIL

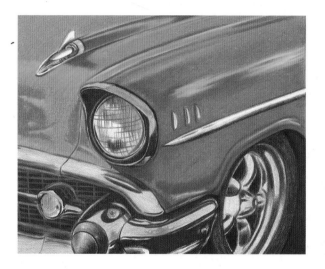

By Eileen Sorg

www.walterfoster.com

CONTENTS

INTRODUCTION

Colored pencils have come a long way from the tools we remember using in grade school. Artists from around the world have picked up these little wood-encased sticks of pigment and taken gallery owners and the viewing public's breath away with their finely crafted works of art. Colored pencils have a multitude of great attributes to offer both the budding and seasoned artist. They are portable, inexpensive, non-toxic, user friendly, and for those interested in exploring their full range, absolutely indispensable. Artistic styles from loose and sketchy to fully developed photorealistic "paintings" can all be achieved through this medium. You are only limited by the boundaries of your own imagination and your willingness to try.

Having always considered myself a draftsman at heart, I have been hooked on colored pencils since being introduced to them many years ago. I am fascinated with the drawn line and the many ways in which a line can be used to describe the world around us. My curiosity and persistence have led me to develop the skills needed to express myself on paper and establish my own unique style. My intentions for this book are to teach you the basic skills needed to get started in colored pencil, and to give you the confidence to keep exploring. I hope these step-by-step lessons spark the same fire in you that began for me so long ago, and that you continue to pursue colored pencil to find your own artistic voice.

Driftwood Recovery Unit

TOOLS AND MATERIALS

Working in colored pencil requires very few supplies, and you may find that you already have many of the items described in this section. As your skills progress you can add more tools to your arsenal and experiment with them along the way. Each project in this book lists the colors needed and provides color swatches, so refer to the individual projects for the colors used.

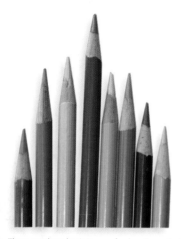

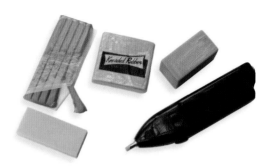

Pencils There are three basic types of colored pencils. I use wax-based pencils, but there are also oil-based pencils (which can be used with wax pencils) and water-soluble pencils (which have a gum binder that reacts to water, similar to watercolor paint). Each brand of pencil has its own characteristics that are worth experimenting with. Many art and craft stores sell pencils individually, making it easy for you to mix and match your pencils as needed.

Erasers The success of erasing your colored pencil marks depends on two main factors: the color of the pencil line and the amount of pressure that was applied. Darker colors tend to stain the paper, making them hard to remove, and heavy lines are hard to erase, especially if the paper's surface has been dented. I usually use a kneaded eraser (top center) and dab at the area to pick up the pigment; wall mounting putty (top left) is very useful when used the same way. For stubborn areas, use a battery-powered eraser (bottom right). Don't use rubber or vinyl erasers (bottom left) to remove colored pencil; the friction between the eraser and the paper can actually melt the wax pigment and flatten the texture of the paper.

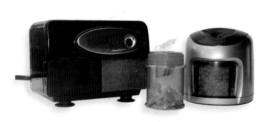

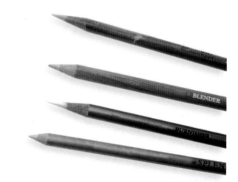

Sharpeners You can achieve various effects depending on how sharp or dull your pencil is, but generally you'll want to keep your pencils sharp at all times. I rarely use handheld sharpeners (above center) because they have a tendency to break the pencil tips and shred the wood, but some artists like them. I prefer a good electric sharpener with auto stop (above left) because it sharpens quickly and cleanly; the auto stop function prevents over-sharpening. If you plan to work outdoors, a battery-powered sharpener (above right) is your best bet. You can also use a sandpaper pad to refine a pencil point.

Colorless Blenders These tools are basically colored pencils without any pigment, and they are great for creating smooth, shiny blends. After applying two or more layers of different colors, work these pencils on top to blend the colors together. The surface of the paper will become a little slick after using a blender, so any colors you add over the blended layer will glide easily on the page. This technique, called "burnishing," is very useful for depicting shiny or wet surfaces. (See page 12 for more information on burnishing.) You can also use blending stumps (tightly wound rolls of paper) or colorless markers.

◀ **Paper** Your choice of paper is the most important factor in how your work will turn out. Many papers will not hold up to the rigors of applying multiple layers of color, so it is worth taking the time to test a new paper before investing a lot of time in a project. If you are planning to use water-soluble pencils, make sure to use watercolor paper. For highly detailed work, I use hot-press watercolor paper, which has a very smooth surface that's ideal for creating delicate details. For work that may need extra layers, I use a sand paper made for pastel artists. You may want to use a rougher paper with more "tooth" (or grain) for landscapes and other pieces that require built-in texture. Always use acid-free paper for your drawings and for mats when framing; otherwise the paper can yellow over time. For practice or drawing quick studies on location, you'll want to have a sketch pad or sketchbook. You might also want to experiment with different colored papers and specialty papers.

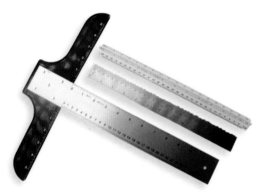

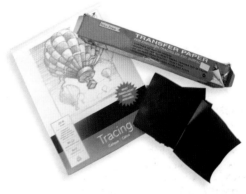

Rulers Use a ruler or T-square to mark the perimeter of your drawing area, ensuring that it is square before taping it to your drawing surface. Never hesitate to use a ruler when drawing to create hard lines that need to be straight, such as the lines of buildings.

Tracing and Transfer Paper I always begin my drawings by sketching the basic outline of the subject and then transferring the sketch to a clean sheet of paper (see page 13 for more information on tracing and transferring). To do this, you'll need tracing paper or transfer paper (similar to carbon paper).

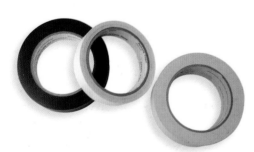

Artist's Tape Use artist's tape to attach your paper to your drawing surface, such as a table or mounting board. This kind of tape is acid-free and can easily be removed without damaging the paper. Even when using this type of tape, take special care when removing the tape. Pull the tape outward, away from your drawing, so that if a tear does start you won't damage your work.

Extras Use a dust brush to gently remove the pencil residue from your paper, as your hand can smear the color and blowing on the paper can leave drops of saliva. You might also want to purchase a can of spray fixative to protect your finished work. I always spray one light coat over my pieces to prevent the whitish-blue haze or wax bloom that can develop when you work with multiple layers of color and apply heavy pressure to the paper.

COLOR BASICS

Colored pencils are transparent by nature, so instead of "mixing" colors as you would for painting, you create blends by layering colors on top of one another. Knowing a little about basic color theory can help you tremendously in drawing with colored pencils. The *primary* colors (red, yellow, and blue) are the three basic colors that can't be created by mixing other colors; all other colors are derived from these three. *Secondary* colors (orange, green, and purple) are each a combination of two primaries, and *tertiary* colors (red-orange, red-purple, yellow-orange, yellow-green, blue-green, and blue-purple) are a combination of a primary color and a secondary color.

▶ **Color Wheel** A color wheel is a useful reference tool for understanding color relationships. Knowing where each color lies on the color wheel makes it easy to understand how colors relate to and react with one another.

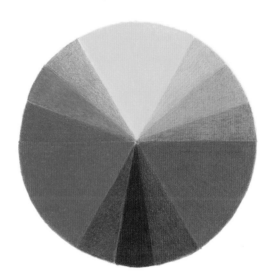

Complementary Colors

Complementary colors are any two colors directly across from each other on the color wheel (such as red and green, orange and blue, or yellow and purple). You can actually see combinations of complementary colors in nature—for instance, if you look at white clouds in a blue sky, you'll notice a hint of orange in the clouds.

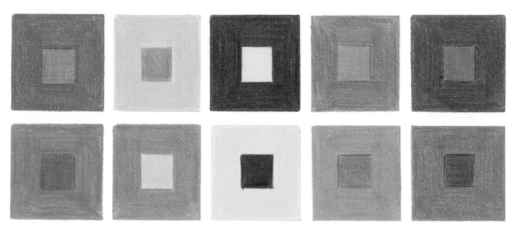

Using Complements When placed next to each other, complementary colors create lively, exciting contrasts. Using a complementary color in the background will cause your subject to seem to "pop" off the paper. For example, you could place bright orange poppies against a blue sky or draw red berries amid green leaves.

Color Psychology

Colors are often referred to in terms of "temperature," but that doesn't mean actual heat. An easy way to understand color temperature is to think of the color wheel as divided into two halves: The colors on the red side are warm, and the colors on the blue side are cool. So colors with red or yellow in them appear warmer, and colors with more green or blue in them appear cooler. For instance, if a normally cool color (like green) has more yellow added to it, it will appear warmer; and if a warm color (like red) has a little more blue, it will seem cooler. Another important point to remember about color temperature is that warm colors appear to come forward and cool colors appear to recede; this knowledge is valuable when creating the illusion of depth in a scene.

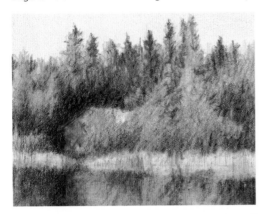 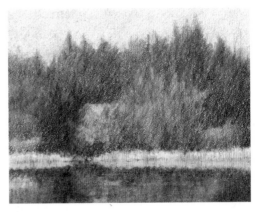

Warm Versus Cool Here the same scene is drawn with two different palettes: one warm (left) and one cool (right). Notice that the mood is strikingly different in each scene. This is because color arouses certain feelings; for example, warm colors generally convey energy and excitement, whereas cooler colors usually indicate peace and calm.

Color Mood The examples here further illustrate how color can be used to create mood (left to right): Complements can create a sense of tension; cool hues can evoke a sense of mystery; light, cool colors can provide a feeling of tranquility; and warm colors can create a sense of danger.

Tints, Shades, and Tones

Colors can be tinted with white to make them lighter, shaded with black to make them darker, or toned with gray to make them more muted. Here each color was applied using graduated pressure—light, then heavy, then light. Black was applied at the top and white at the bottom to tint and tone the colors, respectively. To tint a color without muting it, apply the white first and then the color.

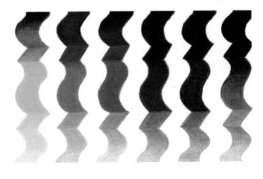

WARMING UP

Just as you warm up before exercising, it helps to limber up your drawing muscles (including the right side of your brain) for the task at hand (pun intended). On a piece of scratch paper, play with different scribbles and lines, change the pressure, and try holding your pencil in a different way. A friend of mine who suffered from Carpal Tunnel Syndrome found that if she held her pencil at the very end like an oil painter holds a brush, she was able to draw comfortably for hours. Her experimentation and passion for art led her to develop a beautiful, unique style of drawing that never ceases to amaze me.

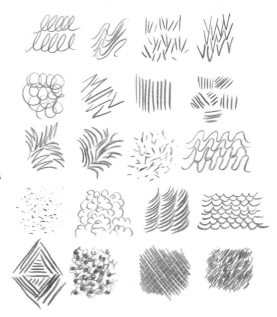

▶ **Experimenting with Lines** I usually warm up by drawing random squiggles and lines. Familiarize yourself with the different types of lines your pencils can create, and experiment with every kind of stroke you can think of, using both a sharp point and a blunt (dulled) point. Practice the strokes at right to help you loosen up.

Holding the Pencil

The way you grip the pencil will have a direct impact on the strokes you create. Some grips will allow you to press more firmly on the pencil, resulting in dark, dense strokes. Others hinder the amount of pressure you can apply, rendering your strokes lighter. Still others give you greater control over the pencil, allowing you to create fine details. Experiment with each of the grips below.

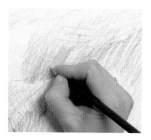

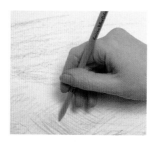

◀ **Conventional Grip** For the most control, grasp the pencil about 1-1/2" from the tip. Hold it the same way you write, with the pencil resting firmly against your middle finger. This grip is perfect for smooth applications of color, as well as for making hatch strokes and small, circular strokes. Try to relax and let the pencil glide across the page.

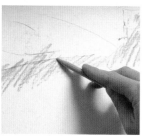

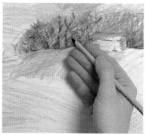

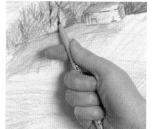

Overhand Grip Guide the pencil by laying your index finger along the shaft. This is the best grip for strong applications of color made with heavy pressure.

Underhand Grip When you cradle the pencil in your hand (as in either example shown above), you control it by applying pressure only with the thumb and index finger. This grip can produce a lighter line, but keep in mind that when you hold the pencil this way, your whole hand should move (not just your wrist and fingers).

CREATING FORM

Value is the term used to describe the relative lightness or darkness of a color (or of black). By adding a range of values to your subjects, you create the illusion of depth and form. Color can confuse our eyes when it comes to value, so a helpful tool can be a black-and-white copy of your reference photo (if you're using one). This will take color out of the equation and leave only the shades of gray that define each form. Value defines form, not color, so if you choose the appropriate values, the color isn't important—you can draw purple trees or blue dogs and still captivate your viewers.

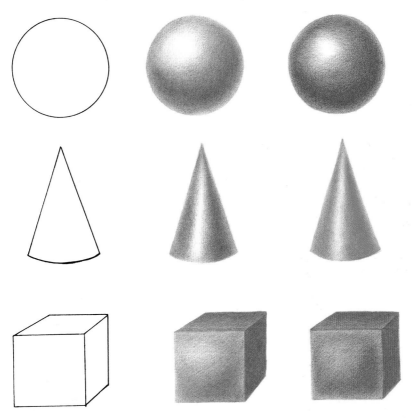

Creating Form with Value In this example, you can see that the gray objects seem just as three-dimensional as the colored objects. This shows that value is more important than color when it comes to creating convincing, lifelike subjects. It's a good idea to practice this exercise before you begin the projects so you can get a handle on applying values. First draw the basic shape. Then, starting on the shadowed side, begin building up value, leaving the paper white in the areas where the light hits the object directly. Continue adding values to create the form of the object. Squint your eyes to blur the details so you can focus on the value changes. Add the darkest values last. As the object gets farther away from the light, the values become darker, so place the darkest values on the side directly opposite the light.

▶ **Value Scale** Another helpful tool for understanding value is a value scale showing the progression from white (the lightest value) to black (the darkest value). Most colored pencil brands offer a variety of grays, which are distinguished by naming them either "warm" or "cool" and then adding a percentage to indicate the concentration of color, such as "cool gray 20%." (Lower percentages are lighter.)

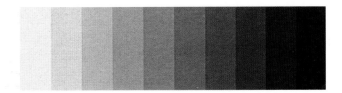

COLORED PENCIL TECHNIQUES

Colored pencil is amazingly satisfying to work with, partly because it's so easily manipulated and controlled. The way you sharpen your pencil, the way you hold it, and the amount of pressure you apply all affect the strokes you create. With colored pencils, you can create everything from soft blends to brilliant highlights to realistic textures. Once you get the basics down, you'll be able to decide which techniques will capture your subject's unique qualities. There are as many techniques in the art of colored pencil as there are effects—and the more you practice and experiment, the more potential you will see in the images that inspire you.

Pressure

Colored pencil is not like paint: You can't just add more color to the tip when you want it to be darker. Because of this, your main tool is the amount of pressure you use to apply the color. It is always best to start light so that you maintain the tooth of the paper for as long as you can. Through practice, you will develop the innate ability to change the pressure on the pencil in response to the desired effect.

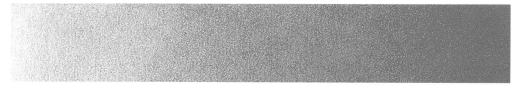

Light Pressure Here color was applied by just whispering a sharp pencil over the paper's surface. With light pressure, the color is almost transparent.

Medium Pressure This middle range creates a good foundation for layering. This is also the pressure you might want to use when signing your drawings.

Heavy Pressure Really pushing down on the pencil flattens the paper's texture, making the color appear almost solid.

Strokes

Each line you make in colored pencil drawing is important—and the direction, width, and texture of the line you draw will contribute to the effects you create. Practice making different types of strokes. You'll find that you have a natural tendency toward one or two strokes in particular, but any stroke you use can help convey texture and emotion in your work.

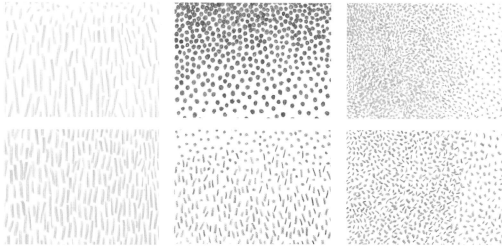

Strokes and Texture You can imitate a number of different textures by creating patterns of dots and dashes on the paper. To create dense, even dots, try twisting the point of your pencil on the paper.

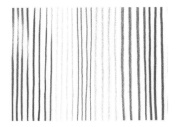

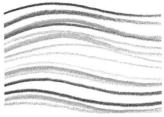

Strokes and Movement While a group of straight lines can suggest direction (above left), a group of slightly curved lines (above right) conveys a sense of motion more clearly. Try combining a variety of strokes to create a more turbulent, busy design. Exercises like these can give you an idea of how the lines and strokes you draw can be expressive as well as descriptive.

Varied Line Try varying the width and weight of the lines you create to make them more textured and interesting. These calligraphic lines can help create a feeling of dimension in your drawing.

Types of Strokes

Circular Move your pencil in a circular motion, either in a random manner as shown here or in patterned rows. For denser coverage as shown on the right side of the example, overlap the circles. You can also vary the pressure throughout for a more random appearance.

Linear It may be more comfortable for you to work in a linear fashion: vertically, horizontally, or diagonally, depending on your preference. Your strokes can be short and choppy or long and even, depending on the texture desired.

Scumbling This effect is created by scribbling your pencil over the surface of the paper in a random manner, creating an organic mass of color. Changing the pressure and the amount of time you linger over the same area can increase or decrease the value of the color.

Hatching This term refers to creating a series of roughly parallel lines. The closer the lines are together, the denser and darker the color. *Crosshatching* is laying one set of hatched lines over another but in a different direction. You can use both of these strokes to fill in an almost solid area of color, or you can use them to create texture.

Smooth No matter what your favorite stroke is, you should strive to be able to control the pencil and apply a smooth, even layer of color. I tend to use small circles, as shown in this example. Note that the color is smooth you can't tell how it was applied.

Stippling This is a more mechanical way of applying color, but it creates a very strong texture. Simply sharpen your pencil and create small dots all over the area. Make the dots closer together for denser coverage.

Layering and Blending

Painters are able to mix their colors on a palette before applying them to the canvas. With colored pencil, all your color mixing and blending occurs directly on the paper. With layering, you can either build up color or create new hues. To deepen a color, layer more of the same over it; to dull it, use its complement. You can also blend colors by burnishing with a light pencil or using a colorless blender (see page 4).

Layering The simplest approach to blending colors together is to layer one color directly over the other. This can be done with as many colors as you think necessary to achieve the color or value desired. The keys to this technique are to use light pressure, work with a sharp pencil point, and apply each layer smoothly.

Burnishing with a Colorless Blender To refresh your memory, burnishing is a technique that requires heavy pressure to meld two or more colors together for a shiny, smooth look. Using a colorless blender tends to darken the colors (as shown above), whereas using a white or light pencil (see below left) lightens the colors and gives them a hazy appearance.

Burnishing Light Over Dark You can also burnish using light or white pencils. To create an orange hue, apply a layer of red and then burnish over it with yellow. Always remember to place the darker color first; if you place a dark color over a lighter color, the dark color will take over and no real blending will occur. Also try not to press too hard on the underlayers of the area you intend to burnish; if you flatten the tooth of the paper too soon, the resulting blend won't be as effective.

Optical Mixing In this method, commonly used in pastel work, the viewer's eye sees two colors placed next to each other as being blended. Scumble, hatch, stipple, or use circular strokes to apply the color, allowing the individual pencil marks to look like tiny pieces of thread. When viewed together, the lines form a tapestry of color that the eye interprets as a solid mass. This is a very lively and fresh method of blending that will captivate your audience.

TRACING AND TRANSFERRING

At the beginning of each project, you'll find a line drawing of the subject that you can photocopy, enlarge, and transfer to your drawing paper. (If you would rather freehand the subject, feel free to do that instead!) Keep in mind that the lines are much darker in this book for reproduction purposes; you should draw your lines very lightly so you can erase them as you start to apply color. There are three main ways to transfer a drawing, which I'll discuss here.

Using a Light Box

A light box is a special desk or inexpensive box with a transparent top and a light inside. The light illuminates papers placed on top and allows dark lines to show through for easy tracing. After photographing and enlarging the line drawing (or sketching it on a piece of scrap paper), tape the sketch to the surface of the light box. Cover the sketch with a sheet of clean drawing paper and flip the switch—the light illuminates the drawing underneath and will help you accurately trace the lines onto the new sheet of paper. You can make your own light box by placing a lamp under a glass table, or you can even tape the sketch and the drawing paper to a glass window and use natural light.

Using Transfer Paper

Another easy method is to trace the image on a sheet of tracing paper and then coat the back of the tracing paper with an even layer of graphite. (Or you can purchase transfer paper, which already has one side coated with graphite, like carbon paper.) Then place the tracing paper over a clean sheet of drawing paper, graphite-side down. Tape or hold the papers together and lightly trace your outline. The lines of your sketch will transfer onto the new sheet of drawing paper.

▶ **Checking Your Lines** While tracing the lines of the sketch, occasionally lift the corner of the sketch (and the coated tracing paper) to make sure the lines that have transferred to the drawing paper aren't too light or too dark.

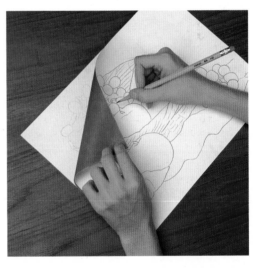

Using the Grid Method

This method helps you break the subject down into smaller, more manageable segments. First photocopy the line drawing and then draw a grid of squares (about 1") over the photocopied image. Then draw a corresponding grid over your drawing paper. The line drawing and the drawing paper must have the same number of squares. Once you've created the grids, simply draw what you see in each square of the line drawing in each square of the drawing paper. Draw in one square at a time until you have filled all the squares.

◀ **Making Grids** Using the lines of the grid squares as reference points, you can accurately position the features of your subject. Make the grid lines light; you'll erase them when done.

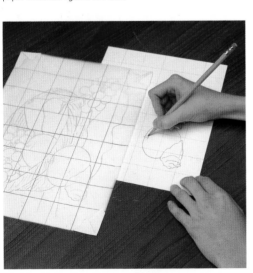

BUTTERFLY

Butterflies offer a world of options when it comes to color and texture. Their wings are velvety and iridescent, allowing for an opportunity to use vivid colors that softly blend together. For the shiny body, burnishing colors together works best; for the hairy areas, use short, linear strokes. This single subject offers many techniques and possibilities for an artist to explore.

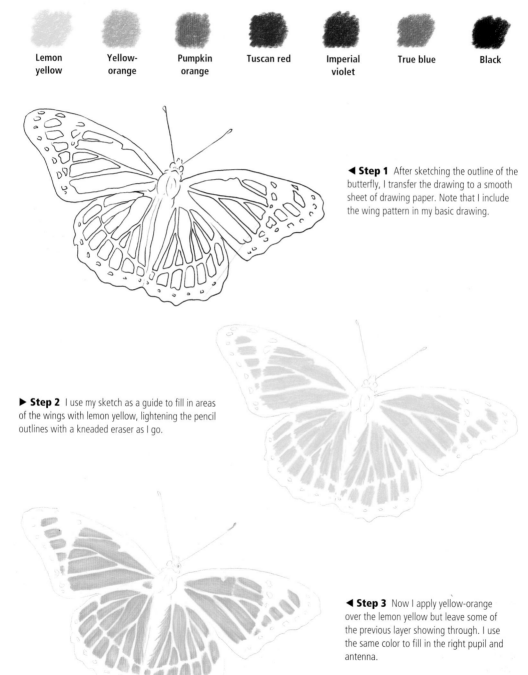

| Lemon yellow | Yellow-orange | Pumpkin orange | Tuscan red | Imperial violet | True blue | Black |

◄ **Step 1** After sketching the outline of the butterfly, I transfer the drawing to a smooth sheet of drawing paper. Note that I include the wing pattern in my basic drawing.

▶ **Step 2** I use my sketch as a guide to fill in areas of the wings with lemon yellow, lightening the pencil outlines with a kneaded eraser as I go.

◄ **Step 3** Now I apply yellow-orange over the lemon yellow but leave some of the previous layer showing through. I use the same color to fill in the right pupil and antenna.

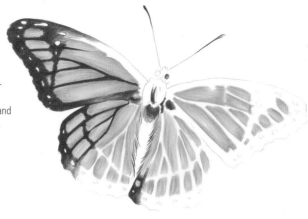

▶ Step 4 I add pumpkin orange over the yellow-orange, letting some orange show through. Then I use Tuscan red to fill in darker areas of the wings and upper body, as well as the right eye and antennae.

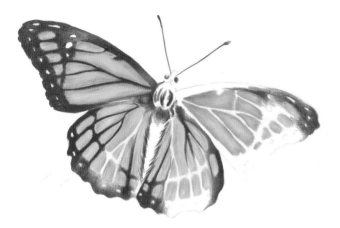

◀ Step 5 I add the purple and blue areas of the wings with imperial violet and true blue. I also add true blue to the left eye and antennae.

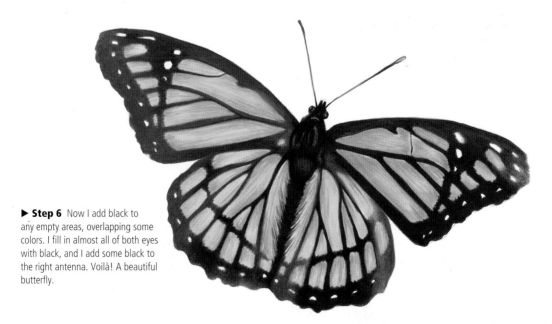

▶ Step 6 Now I add black to any empty areas, overlapping some colors. I fill in almost all of both eyes with black, and I add some black to the right antenna. Voilà! A beautiful butterfly.

FISH IN BOWL

When drawing subjects that are transparent like this fishbowl, you are actually rendering the reflections on its surface. Clear glass and water have little or no color of their own, so the colors you see and use are reflected from the objects around them. In this example, I use mostly grays and blues, but all the colors under the rainbow are possible options. Just draw what you see and be open to using all the colors you observe.

| Cool gray 30% | Warm gray 50% | Light cerulean blue | Slate gray | Deco yellow | Lavender | Pale vermilion | Black | Scarlet lake |

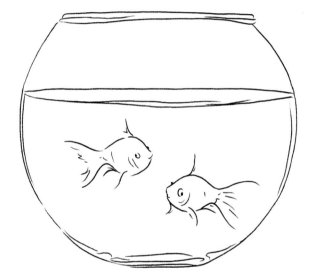

▶ **Step 1** I use very light lines to transfer the basic outline onto drawing paper.

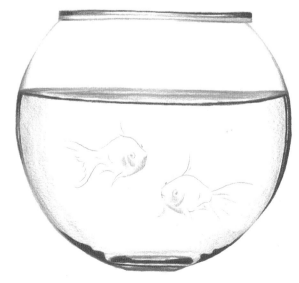

◀ **Step 2** I use cool gray 30% to outline the shape of the fishbowl and shade areas of the goldfish. Then I add darker outlines to the bowl using warm gray 50%. I bring in some light cerulean blue for the water. Next I add slate gray to the bottom of the bowl and along the surface of the water.

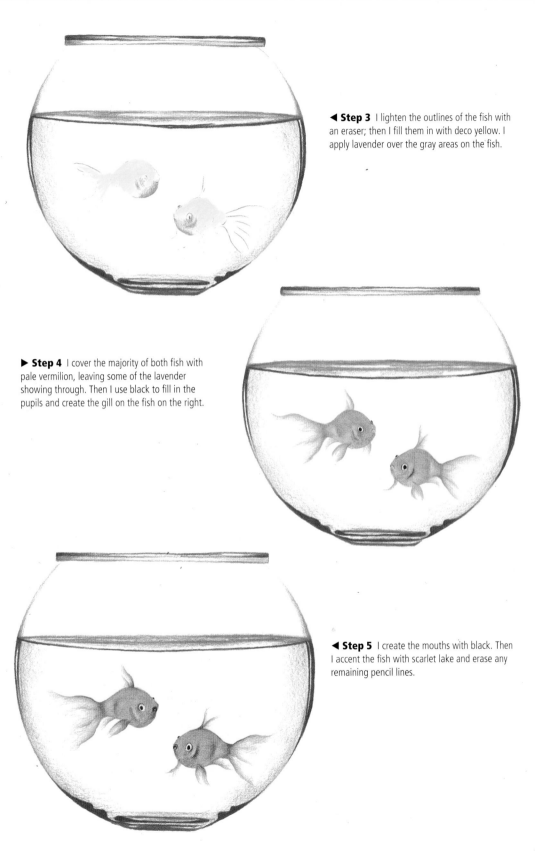

◄ **Step 3** I lighten the outlines of the fish with an eraser; then I fill them in with deco yellow. I apply lavender over the gray areas on the fish.

► **Step 4** I cover the majority of both fish with pale vermilion, leaving some of the lavender showing through. Then I use black to fill in the pupils and create the gill on the fish on the right.

◄ **Step 5** I create the mouths with black. Then I accent the fish with scarlet lake and erase any remaining pencil lines.

PARROT

When drawing animals, it's a good idea to use photo references as guides. It's nearly impossible to find an animal that will sit still long enough for you to draw it from life (except maybe a sloth). For this parrot, I use a limited palette of six colors to bring to life its vibrant green and yellow feathers. Drawing the parrot's head at a tilted angle like this gives the composition more interest.

Sunburst yellow

Warm gray 90%

Pumpkin orange

Parrot green

Limepeel

Black

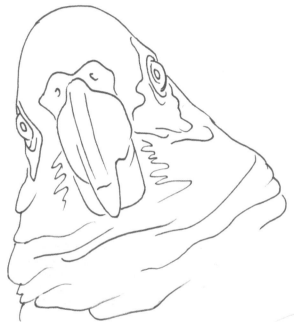

◄ **Step 1** I transfer my drawing of the parrot to a smooth sheet of drawing paper, including lines that suggest the light and dark areas of the parrot.

▶ **Step 2** I start by applying sunburst yellow around the eyes and beak, lightening the pencil outline with an eraser as I go. Then I fill in the pupils and other areas of the eyes with warm gray 90%, being sure to leave circular highlights in each eye. I apply this same color all over the beak, varying the pressure and leaving some areas white to suggest the overall shape. Using warm gray 90% and vertical strokes, I fill in the feathers above and on the sides of the beak, as well as some random feathers on the neck and chest.

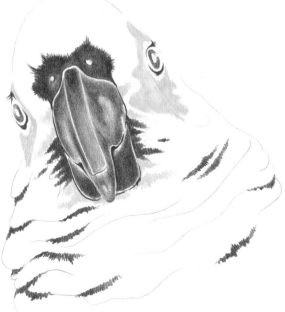

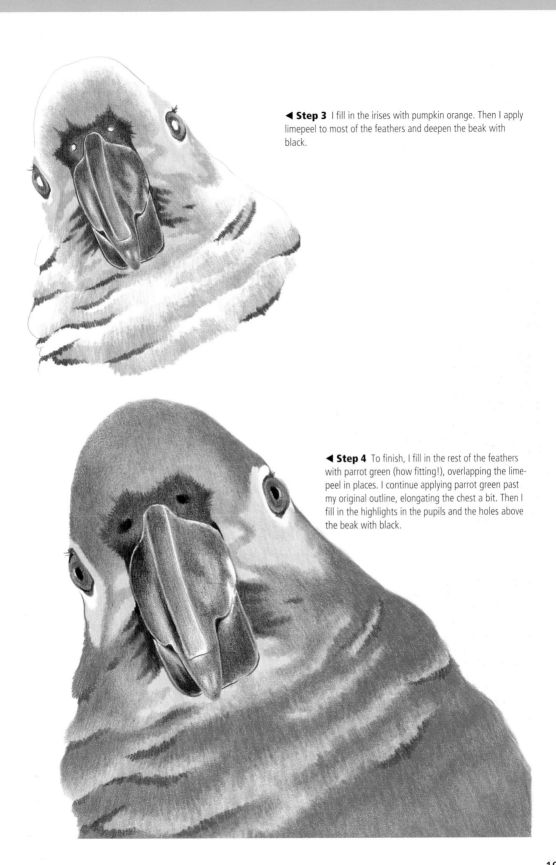

◄ Step 3 I fill in the irises with pumpkin orange. Then I apply limepeel to most of the feathers and deepen the beak with black.

◄ Step 4 To finish, I fill in the rest of the feathers with parrot green (how fitting!), overlapping the lime-peel in places. I continue applying parrot green past my original outline, elongating the chest a bit. Then I fill in the highlights in the pupils and the holes above the beak with black.

GUMBALL MACHINE

This colorful gumball machine is a great exercise for letting your colored pencils really shine. Highly reflective surfaces like the glass and metal in this project are best described using a lot of contrast, or lights next to darks. Allow some of the white of the paper to show through the color for the brightest reflections. When dark colors are applied around the highlights, the shine of the metal begins to unfold.

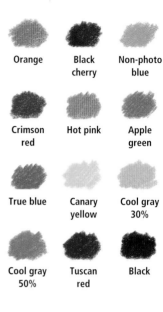

Orange	Black cherry	Non-photo blue
Crimson red	Hot pink	Apple green
True blue	Canary yellow	Cool gray 30%
Cool gray 50%	Tuscan red	Black

Step 1 I draw the basic outline of the gumball machine and add circles inside the glass portion for the candy. Then I transfer my sketch to drawing paper.

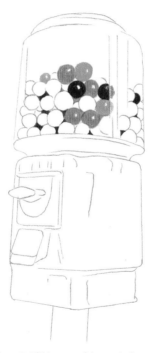

Step 2 I fill in some of the gumballs using orange, black cherry, non-photo blue, crimson red, hot pink, and apple green, leaving a small highlight in most of the circles to show the reflective surface. Note that I use lighter pressure where the gumballs are seen through the rounded corners of the glass.

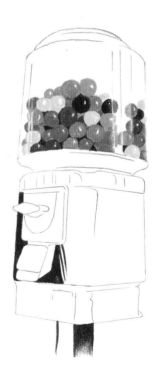

Step 3 I fill in the remaining gumballs with true blue and canary yellow, and then I start shading the shadowed areas of the machine's base with Tuscan red.

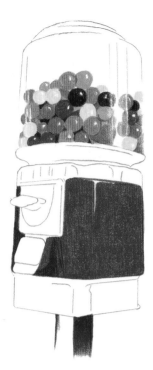

Step 4 Now I create the lighter sides of the machine's base with crimson red. Note that I leave an area of white on the corner to suggest the shiny metal surface.

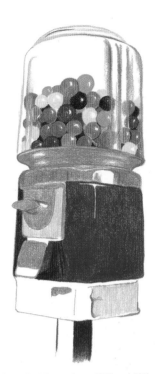

Step 5 Using cool gray 20% and 50%, I create the chrome on the machine, adding accents with touches of true blue. I leave some areas of the paper white to show the shiny surface.

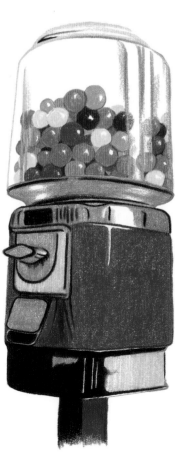

▶ **Step 6** To finish, I add black to several areas of the machine, including the top part of the glass.

FRUIT STILL LIFE

When setting up a still life, it's a good idea to use odd numbers (like the three strawberries) to create visual interest. It's also helpful to overlap the objects, as you see here. Fruit is a great study in texture; in this project, the smooth surface of the grapes nicely contrasts with the rough texture of the strawberries.

 Poppy
red

 Crimson
red

 Tuscan
red

 Limepeel

 Grass
green

Dark
green

Light
cerulean
blue

Yellowed
chartreuse

Canary
yellow

Cool gray
30%

French
gray 90%

Green
ochre

Black

Burnt
ochre

◄ **Step 1** As always, I transfer my line drawing to a clean sheet of paper.

▶ **Step 2** To create the strawberry seeds, I cover my drawing with a sheet of tracing paper and use the tip of a ballpoint pen to indent dots into the strawberries. When I remove the tracing paper and cover the strawberries with poppy red, white dots will appear through the color. Note that I leave areas of the berries white for highlights.

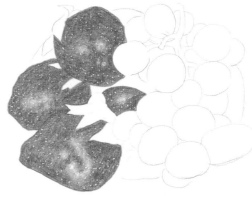

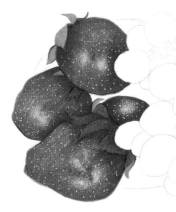

◄ **Step 3** Now I darken the strawberries with crimson lake and Tuscan red, maintaining the highlights. Next I create the lighter leaves with limepeel and the darker leaves with grass green. I apply dark green for the shadows.

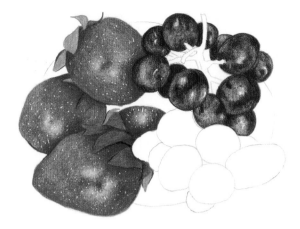

◄ Step 4 Now I fill in about half of the grapes with a layer of black raspberry, making this layer uneven with lighter and darker spots and white highlights.

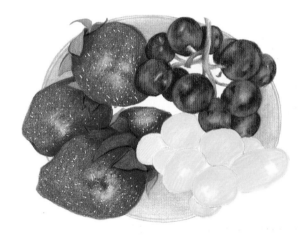

► Step 5 Next I apply a layer of light cerulean blue to the grapes and blend it with the previous layer. I fill in the stem with green ochre and burnt ochre. Then I start the green grapes by applying a layer of yellowed chartreuse and canary yellow, again leaving white highlights. I also shade most of the bowl with cool gray 30%.

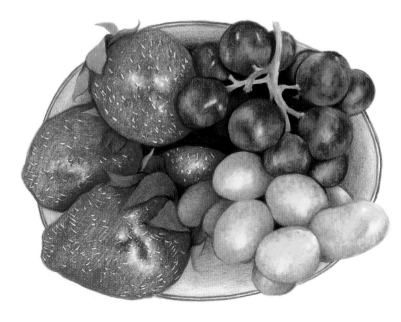

◄ Step 6 After shading the green grapes with layers of limepeel and green ochre, I use a white pencil to lighten the highlights on all the fruit. Then I use black to darken the areas between and beneath the fruit. Finally, I use French gray 90% to darken the bowl and refine the rim.

PINK FLAMINGO

I create the plastic-looking texture of this retro yard decoration by building up multiple layers of color. The success of layering depends on your ability to apply color smoothly and evenly. By keeping the edges indistinct and avoiding harsh lines, you can create soft blends that will define the shape of the flamingo's body.

Black

Spanish orange

Magenta

Black cherry

Carmine red

Blush pink

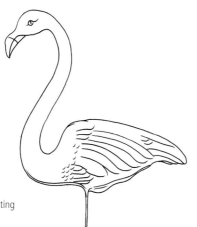

▶ **Step 1** After creating a line drawing of the flamingo, I transfer the drawing to a clean sheet of paper.

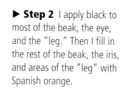

▶ **Step 2** I apply black to most of the beak, the eye, and the "leg." Then I fill in the rest of the beak, the iris, and areas of the "leg" with Spanish orange.

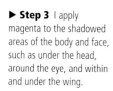

▶ **Step 3** I apply magenta to the shadowed areas of the body and face, such as under the head, around the eye, and within and under the wing.

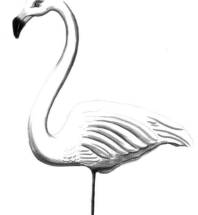

▶ **Step 4** I further define the shadows with accents of black cherry.

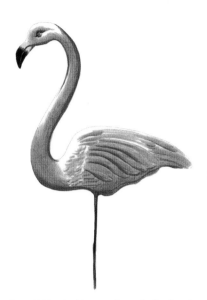

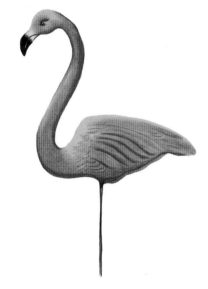

Step 5 Now I add more color to the flamingo by building up layers of carmine red, leaving some of areas of the head and body free of color for now.

Step 6 Using blush pink and a greater amount of pressure, I fill in all the white areas from the previous step. I also layer over all the carmine red areas to blend the two colors together.

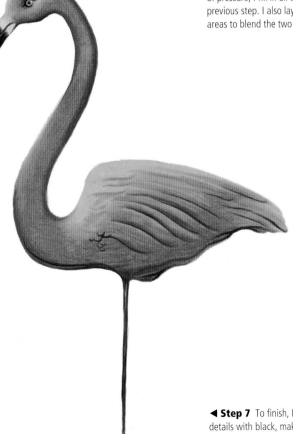

◄ **Step 7** To finish, I refine the feathers and details with black, making them really stand out.

RED-EYED TREE FROG

When drawing animals like this tree frog, subtle shifts in color and value are important for defining the animal's anatomy. In this project, the grays on the throat and the oranges on the feet are layered to help create the illusion of roundness and dimension. Delicately changing the amount of pressure you use when applying color is very helpful to create realism when drawing live subjects.

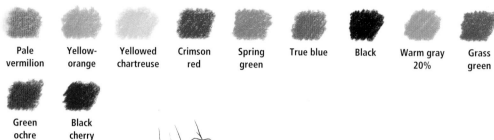

| Pale vermilion | Yellow-orange | Yellowed chartreuse | Crimson red | Spring green | True blue | Black | Warm gray 20% | Grass green |

| Green ochre | Black cherry |

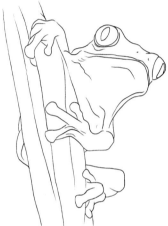

◄ **Step 1** After drawing the basic outlines of the tree frog and the plant stalk, I transfer the sketch to drawing paper.

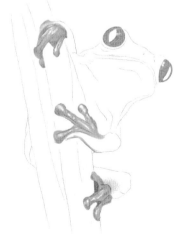

◄ **Step 2** I apply pale vermilion to the eyes and parts of the feet; then I fill in the rest of the feet with yellow-orange, leaving tiny areas white for highlights.

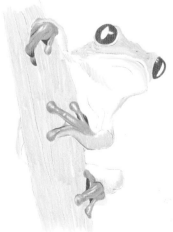

▶ **Step 3** I create the base layer for both the frog and the stalk with chartreuse, leaving areas of the frog white for now. Then I apply crimson red to the eyes and the deepest shadows on the feet.

◄ **Step 4** I use spring green on the stalk and the frog's eyes and legs. Then I apply true blue to the frog's mouth, legs, and parts of the chest.

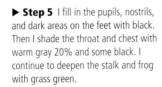

▶ **Step 5** I fill in the pupils, nostrils, and dark areas on the feet with black. Then I shade the throat and chest with warm gray 20% and some black. I continue to deepen the stalk and frog with grass green.

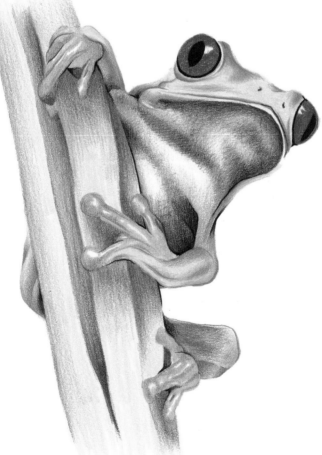

◄ **Step 6** I add shadows to the stalk with a layer of green ochre followed by black cherry. To finish, I use black cherry to brighten up the shadows on the frog's throat and chest.

DAISY

When drawing very pale subjects, artists often use *negative space,* or the space around the subject, to describe the object itself. In this case, the blue sky is what really gives shape and identity to the daisy's petals. Because the flower is white, much of its color is derived from its surroundings. Using the blues and greens from the sky and the leaves gives the flower its shape and keeps the subject tied into its environment.

Lemon yellow	Mineral orange	Pale vermilion	Terra cotta	Dark umber	Limepeel	Artichoke	Cool gray 50%	Lilac

Imperial violet	Black	True blue

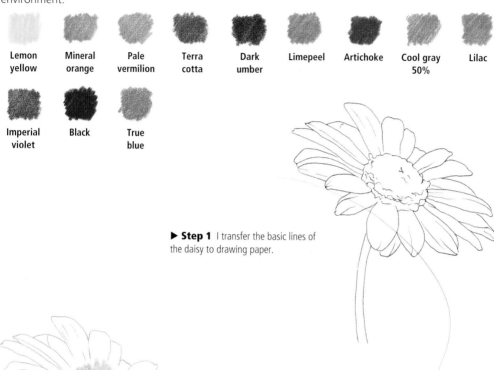

▶ **Step 1** I transfer the basic lines of the daisy to drawing paper.

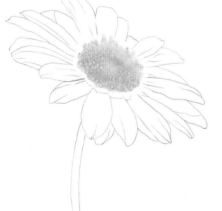

◀ **Step 2** I apply an even layer of lemon yellow to the center of the daisy, and then I add some mineral orange. Next I apply pale vermilion with circular strokes to create the texture of the florets.

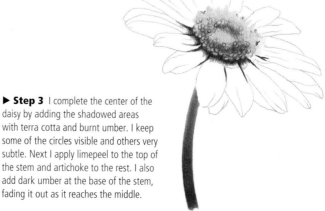

▶ **Step 3** I complete the center of the daisy by adding the shadowed areas with terra cotta and burnt umber. I keep some of the circles visible and others very subtle. Next I apply limepeel to the top of the stem and artichoke to the rest. I also add dark umber at the base of the stem, fading it out as it reaches the middle.

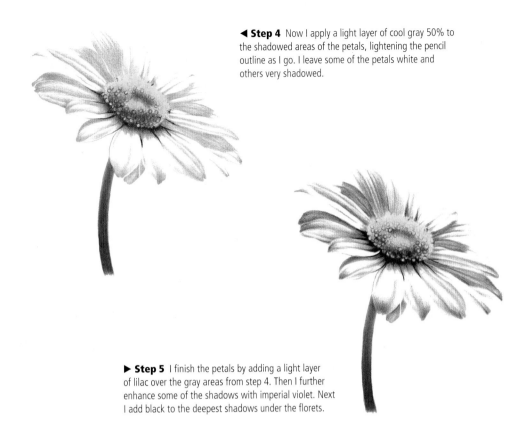

◀ **Step 4** Now I apply a light layer of cool gray 50% to the shadowed areas of the petals, lightening the pencil outline as I go. I leave some of the petals white and others very shadowed.

▶ **Step 5** I finish the petals by adding a light layer of lilac over the gray areas from step 4. Then I further enhance some of the shadows with imperial violet. Next I add black to the deepest shadows under the florets.

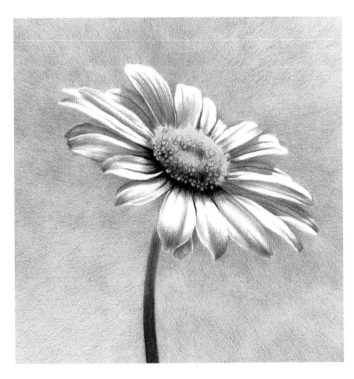

◀ **Step 6** Using true blue and varying amounts of pressure, I create the sky, taking my time to make sure I'm applying the color smoothly. Coloring in this negative space defines the edges of the petals and makes the flower stand out.

SHOES

Black objects are typically very reflective; just like white objects, they are best described by the addition of the colors that are reflected by their surroundings. By doing this, the artist adds life and interest to an otherwise monochromatic subject. Even something as simple as men's dress shoes becomes exciting through an artist's skilled use of color.

| Warm gray 30% | Warm gray 70% | Black | Aquamarine | Parma violet | Magenta | Pale vermilion |

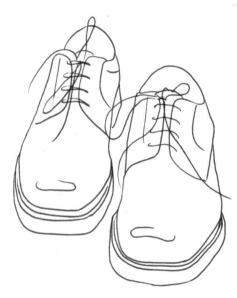

◄ **Step 1** After drawing the shoes, I carefully transfer the lines to drawing paper. Note that I include the areas of reflected light on the toes in my initial sketch.

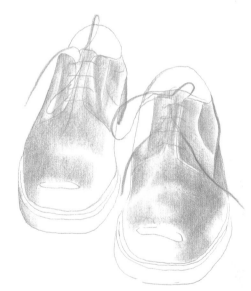

▲ **Step 2** I start applying light layers of warm gray 30% to the shoes, leaving areas white for further layers and highlights.

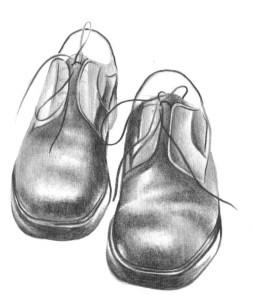

◄ **Step 3** Now I layer slightly darker warm gray 70% on top of the previous layer, still leaving the white of the paper showing in areas. I also outline the shoes and some of the laces, using heavier pressure for darker tones.

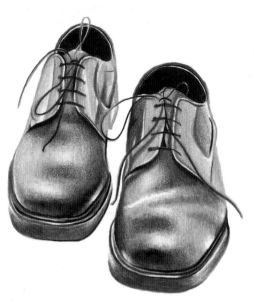

◄ **Step 4** Now I shade the darkest areas with black and finish the laces. Note that I leave some areas white for highlights. Next I apply some aquamarine to begin the color reflections.

▶ **Step 5** I add a layer of parma violet for more color.

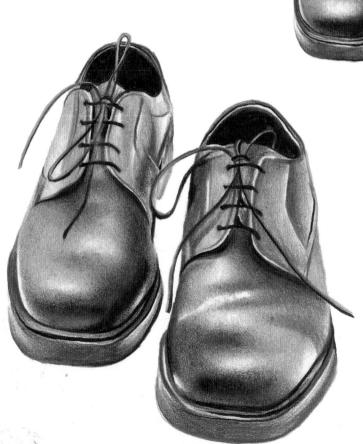

◄ **Step 6** To finish, I apply accents of pale vermilion and magenta to both shoes and parts of the inner and outer rims and laces.

CAFÉ SIGN

This classic café sign is a great project to practice creating controlled edges and soft color blends. The sky and clouds need to be kept very soft, so the blue must be added slowly and smoothly, whereas the sign and the lettering have very defined, crisp edges. In this project, your pencil point is an important tool. Use a sharp point for crisp lines and edges, and use a slightly dulled pencil for the softer sky to avoid creating harsh lines.

Pale vermilion	Jasmine	Espresso	Yellow ochre	Mineral orange	Poppy red	Tuscan red	Non-photo blue	French gray 20%

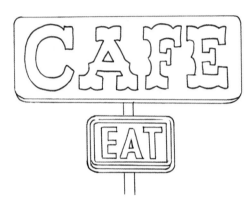

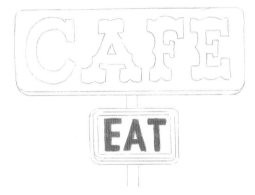

Step 1 First I transfer the line drawing of the sign to a clean sheet of drawing paper.

Step 2 Next I fill in the word "Eat" with pale vermilion.

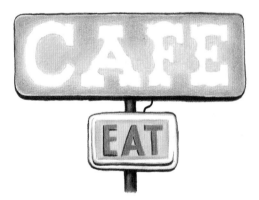

Step 3 Now I create the base layer of both sections of the sign with jasmine, avoiding the "Cafe" letters.

Step 4 I outline both sections of the sign and the wire connecting them with espresso, and I add shadows to the red letters. I also use espresso to fill in the post, leaving the center lighter to suggest a highlight. Then I apply French gray 20% to this lighter area and blend the colors. To give the sign an aged look, I apply some yellow ochre and then mineral orange to the areas that are already covered in jasmine. Note that I leave parts of the "Eat" sign white to suggest a shiny surface.

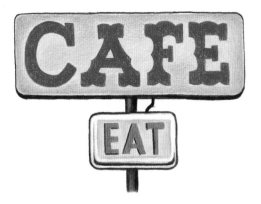

◀ **Step 5** Next I fill in the word "Cafe" with poppy red, and I add more espresso to deepen the dark areas.

▶ **Step 6** Now I use Tuscan red to add shadows to the red "Cafe" letters; I also add more yellow ochre and mineral orange to both sections of the sign.

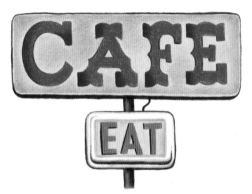

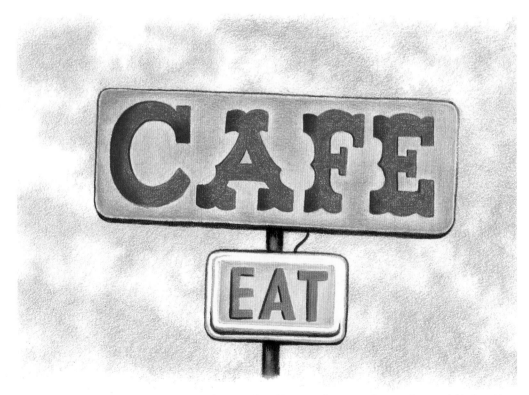

Step 7 To finish, I create the sky using smooth, soft strokes of true blue. I vary the amount of pressure for a mottled look, and I leave several areas white for the clouds.

TURTLE

Multiple layers of color and a unique texture are what make this turtle a great project. Starting with the lightest and brightest yellows and oranges and working into the darker browns, you will see the image start to unfold. Be sure to leave some areas of the yellow showing so that you keep the full range of colors. I chose to add some magenta to the turtle to liven things up, but you could certainly add other colors like purple in the shadows or some greens to offset the oranges. If used in moderation, these unexpected touches of color can really make your artwork come to life.

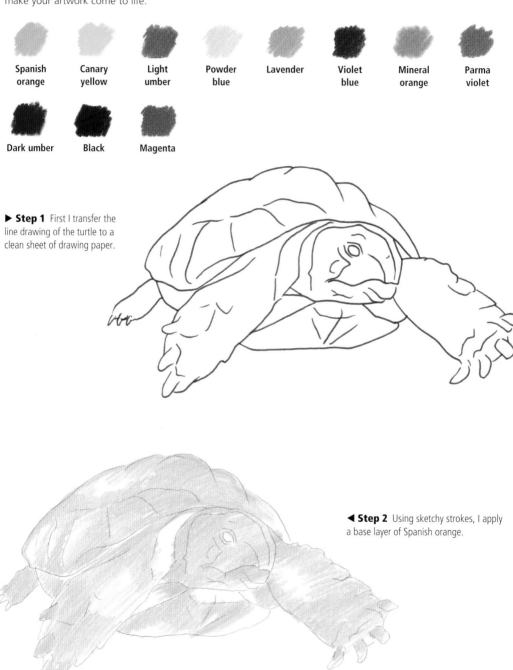

Spanish orange Canary yellow Light umber Powder blue Lavender Violet blue Mineral orange Parma violet

Dark umber Black Magenta

▶ **Step 1** First I transfer the line drawing of the turtle to a clean sheet of drawing paper.

◀ **Step 2** Using sketchy strokes, I apply a base layer of Spanish orange.

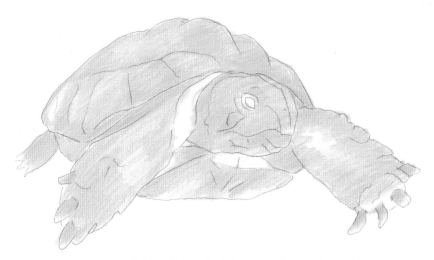

Step 3 I brighten things up by placing canary yellow over the Spanish orange in some areas.

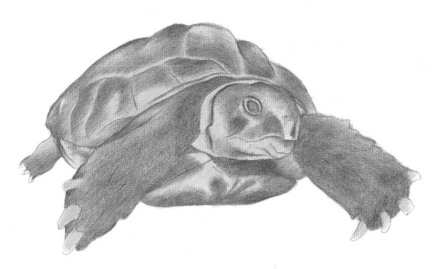

Step 4 Now I begin to darken areas and define the turtle's shape with light umber. I also fill in the eye and parts of the face and shell.

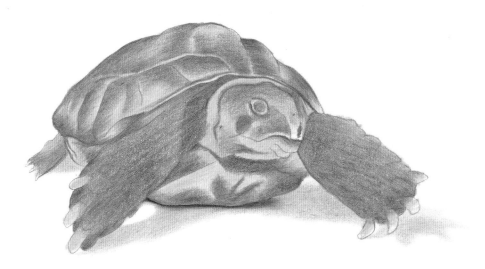

Step 5 Next I create the cast shadow with powder blue, placing a layer of lavender on top of the blue. I apply violet blue directly underneath the turtle's body.

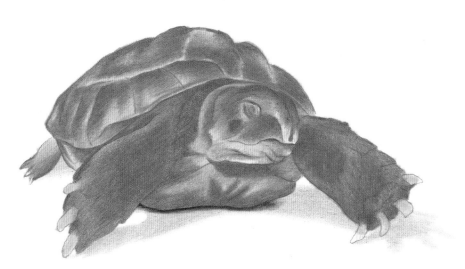

Step 6 I build up more depth by adding mineral orange and parma violet on areas of the turtle.

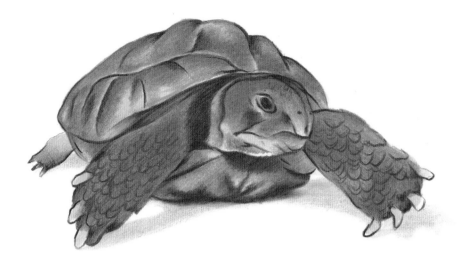

Step 7 I use dark umber to really deepen the shadows and describe the surface of the turtle's shell. I also fill in the nostrils and pupil, and I create scales on the front legs with half-circles and wrinkles on the face.

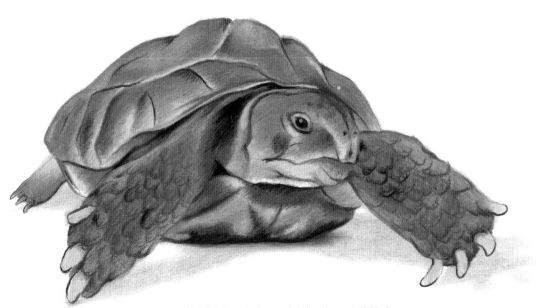

Step 8 I add the darkest shadows and darken the eye with black. As a final touch, I place some magenta in a few areas all over the turtle.

MAI TAI

The two great elements of this project are the fabulous range of colors and the contrast between the structured and organic shapes. When drawing subjects that are symmetrical, like this glass, it is important to keep your lines precise and unwavering. Take your time when defining the edges and rim of the glass so the shape stays accurate. On the other hand, you should draw the ice cubes and fruit in a looser, more organic manner. You are free to change the shapes, add another cherry—whatever suits your artistic vision.

Lemon yellow	Sunburst yellow	Olive green	Sienna brown	Black
Tuscan red	Crimson lake	Pale vermilion	Dark brown	Grass green
Warm gray 70%	Terra cotta	Warm gray 20%		

◀ **Step 1** First I transfer the line drawing to a clean sheet of drawing paper. Note that I outline the areas of light and shadow in my sketch.

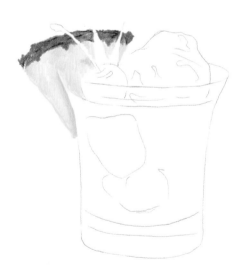

▶ **Step 2** I apply a layer of lemon yellow to the pineapple, darkening the color in places with sunburst yellow. For the skin I use olive green, sienna brown, and a touch of black.

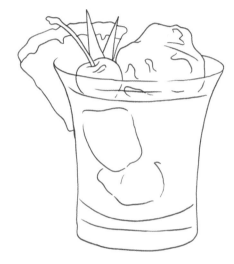

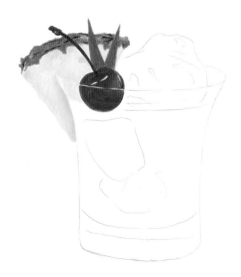

◀ **Step 3** For the cherry, I apply Tuscan red and layer over it with crimson lake, leaving some white highlights. Then I add a touch of pale vermilion to the right side to brighten it up. I fill in the stem with dark brown and Tuscan red, and I create the leaves with olive green and grass green.

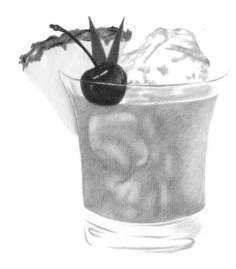

◀ **Step 4** I start the drink with a layer of pale vermilion, using lighter pressure around the ice cubes. Then I add touches of pale vermilion on the ice cubes and at the base of the glass for reflections.

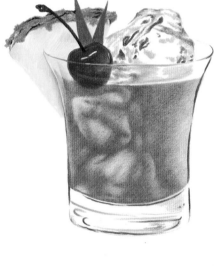

▶ **Step 5** Now I darken the liquid using terra cotta, and I add shadows to the floating ice cube with warm gray 70%. I also outline the glass with gray.

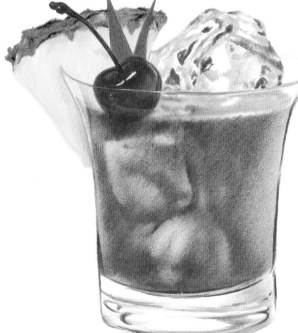

◀ **Step 6** I add Tuscan red to the liquid for the deepest shadows. As a final touch, I apply some warm gray 20% to the floating ice cube and at the base of the glass. Bottoms up!

CLASSIC CAR

Drawing cars and other man-made objects requires an artist to pay special attention to every line. You may want to use a ruler to keep your lines straight and smooth, as the accuracy of your lines helps convey the mechanical nature of the subject. Another fun aspect of cars is the shiny quality of the paint, which you can achieve by placing light and dark colors close together. This high contrast will help indicate a slick, shiny surface.

| Spanish orange | Non-photo blue | Poppy red | Crimson red | Pale vermilion | True blue | Tuscan red | Warm gray 90% | True green |

▶ **Step 1** I carefully transfer the line drawing onto a clean sheet of acid-free, cotton drawing paper.

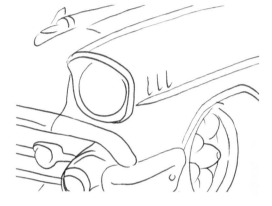

◀ **Step 2** Next I sketch in the first layers with Spanish orange and begin the chrome with non-photo blue.

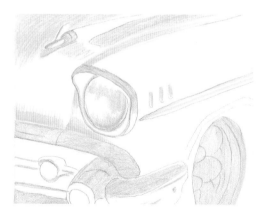

▶ **Step 3** I add a smooth layer of poppy red over the hood and fender, leaving some areas lighter than others for the highlights.

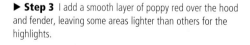

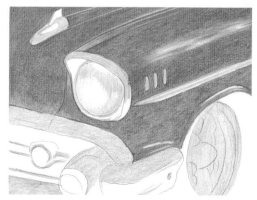

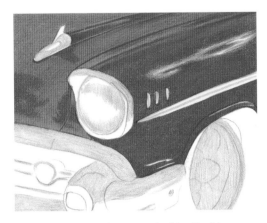

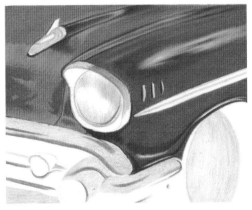

Step 4 Now I deepen the paint on the right side of the car with crimson red and then add a layer of pale vermilion to the left, lighter side of the car. I keep my strokes as smooth as possible to mimic the smooth paint.

Step 5 I use Tuscan red to create the darkest reflections in the paint and add white to the highlights on the paint. I add back some of the Spanish orange to brighten up areas on the left side of the car. I place touches of true blue on the chrome over the non-photo blue.

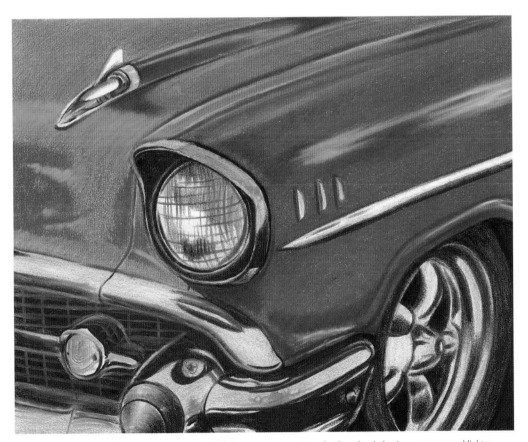

Step 6 To complete the chrome, I use warm gray 90%. I vary my pressure to make the color darker in some areas and lighter in others and work around the car to define the reflections and tire. I add some touches of true green and crimson red into the reflections in the chrome. Finally, I use white to sketch in the grill details.

GIRAFFE

Complimentary colors are often used in art as a way of making drawings and paintings more interesting and lifelike. Most of the colors in this giraffe are what you would expect: warm yellows, browns, and oranges. The addition of blue to the shadows on the giraffe's face is an unexpected choice, but it really adds to the overall effectiveness of the drawing. It not only darkens the shadows, but it also makes the other colors appear more vibrant and natural.

| Jasmine | Yellow ochre | Periwinkle | Terra cotta | Olive green | Light umber | Mineral orange | Black |

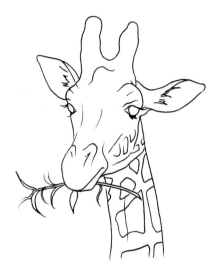

Step 1 I transfer the line drawing to a clean sheet of drawing paper, filling in the giraffe's spots and adding the branch.

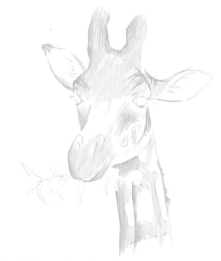

Step 2 I create a base layer of jasmine and apply darker yellow ochre in areas.

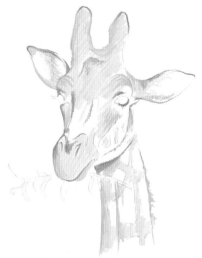

Step 3 Now I suggest some shadows on and around the with periwinkle. Note the shadow cast by the chin onto the neck.

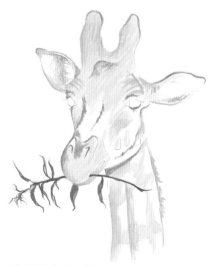

Step 4 I fill in the branch, using terra cotta for the stem and olive green for the leaves.

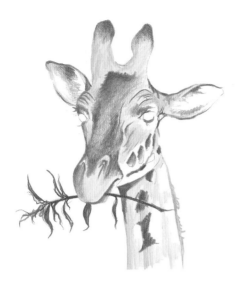

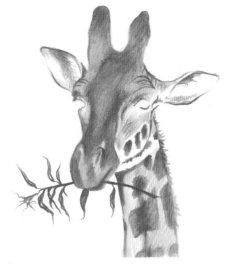

Step 5 Turning back to the face, I apply light umber to further deepen the existing periwinkle shadows, blending the colors together. I also fill in some of the spots and add ridges around the eyes.

Step 6 Now I add some color with mineral orange, placing it all over the giraffe (especially near the muzzle and the forehead). I also fill in more spots and add more hair along the neck.

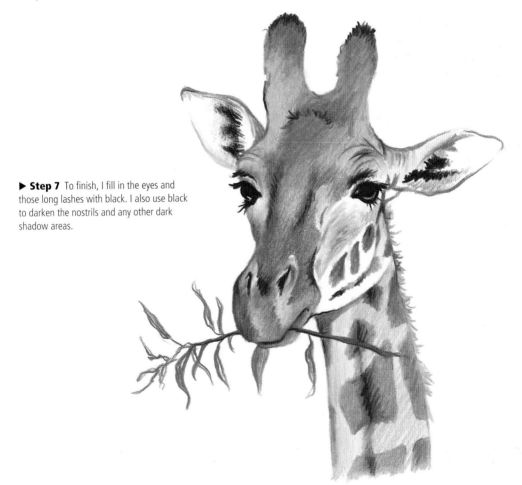

▶ **Step 7** To finish, I fill in the eyes and those long lashes with black. I also use black to darken the nostrils and any other dark shadow areas.

43

HORSE

When drawing with colored pencils (or any medium, for that matter), you have the right to make changes to your subject or composition from the actual reference. For example, most horses don't have bright orange manes like mine does here. But I think the vibrant oranges and yellows make the composition more visually interesting than a horse with a dull brown or black mane. It's your artwork; make it truly your own!

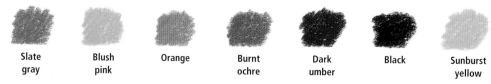

| Slate gray | Blush pink | Orange | Burnt ochre | Dark umber | Black | Sunburst yellow |

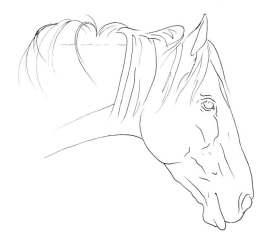

◄ **Step 1** After drawing the horse's head, I transfer the basic outlines to drawing paper.

▶ **Step 2** I shade areas on the muzzle and around the eye with slate gray; then I add some blush pink to areas on the muzzle and nose.

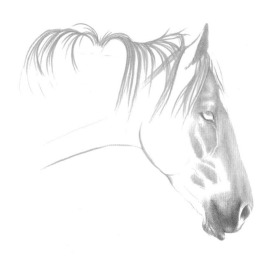

◄ **Step 3** I lightly stroke orange on the upper part of the face and nose, as well as around the muzzle, jaw, and neck. I use the same color and heavier pressure for the inner ear, mane, and eyelashes.

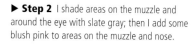

Step 4 I fill in the rest of the head and neck with burnt ochre, avoiding the orange areas. Then I go over the outline of the eye with dark umber.

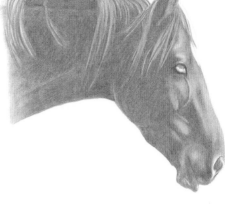

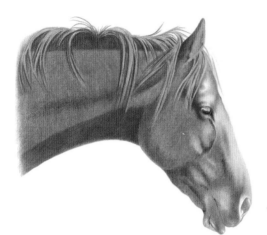

Step 5 Now I apply dark umber over the burnt ochre along the base of the mane, behind the ear and jaw, and around the eye. I fill in the iris with the same color.

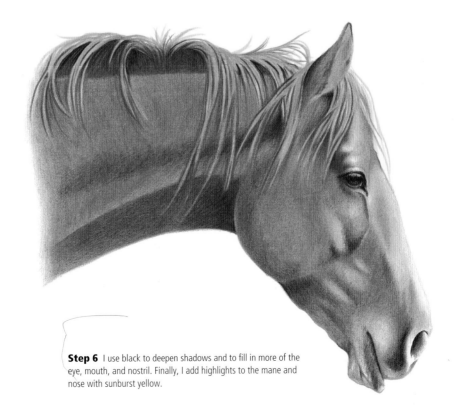

Step 6 I use black to deepen shadows and to fill in more of the eye, mouth, and nostril. Finally, I add highlights to the mane and nose with sunburst yellow.

GARDEN GNOME

This project features another man-made object, the garden gnome, which is traditionally molded from terra cotta clay and then painted. Unlike the classic car exercise that includes precise, hard lines to illustrate the car's metallic surface, you'll want to create soft lines to convey the organic nature of the gnome's composition. I have selected classic colors for this gnome, but I encourage you to experiment with others should the gnome of your imagination spring from a different color palette!

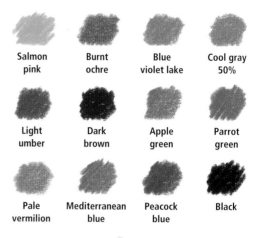

Salmon pink	Burnt ochre	Blue violet lake	Cool gray 50%
Light umber	Dark brown	Apple green	Parrot green
Pale vermilion	Mediterranean blue	Peacock blue	Black

◄ Step 1 Paying special attention to the placement of the facial features, I transfer the line drawing onto a clean sheet of acid-free, cotton drawing paper.

◄ Step 2 Then I use salmon pink to color in the skin tone of the gnome's face, ears, and wrists.

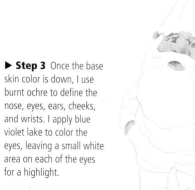

▶ Step 3 Once the base skin color is down, I use burnt ochre to define the nose, eyes, ears, cheeks, and wrists. I apply blue violet lake to color the eyes, leaving a small white area on each of the eyes for a highlight.

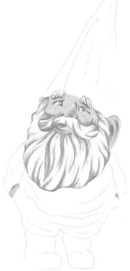

▶ Step 4 I add some lines of cool grey 50% to the beard. This color defines the shadows while the white of the paper helps to suggest the overall color of the beard.

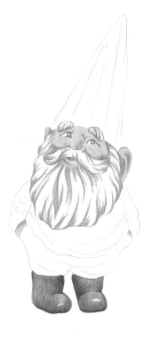

◄ Step 5 I use a layer of light umber for the gnome's boots and define them further by adding dark brown in places as indicated.

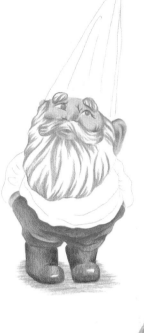

◄ Step 6 For the pants, I add a single layer of apple green and then apply parrot green to create wrinkles and folds. I also use apple green to suggest some grass under his feet.

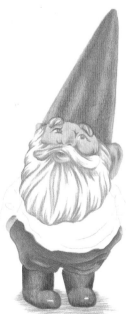

◄ Step 7 Next I create the gnome's signature hat with a single layer of pale vermilion. I add dimension by varying my pressure to create highlights and shadows.

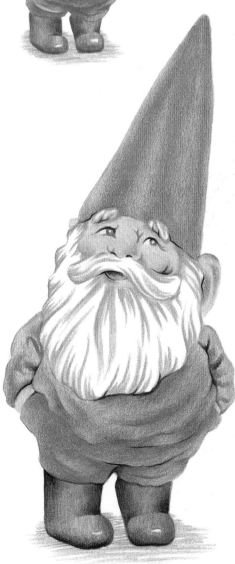

▶ Step 8 For the shirt, I start with a layer of Mediterranean blue and then add in the folds using peacock blue. I apply black for all the areas that are in deeper shadows. I then finish up with black around the eyes and face to add interest.

GUINEA PIG

This silky little guinea pig is so cute and inquisitive. In order to achieve the soft look of its fur it is best to keep your pencil very sharp and work in the direction of the hair growth. Short, even strokes that are very close together helps suggest the fur and the texture, without drawing in too much. Another important element in this drawing is the bright white highlight in the eyes. Be sure to leave these little dots of white free of any colored pencil so the eyes appear nice and bright.

 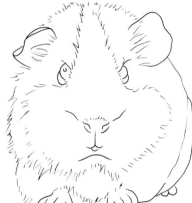

| Mineral orange | Blush pink | Hot pink | Burnt ochre | Sand | Espresso | Cool gray 30% | Blue violet lake | Black |

◄ **Step 1** I transfer my line drawing of this fluffy guinea pig to drawing paper.

▶ **Step 2** I start laying down the fur with mineral orange, following the direction of hair growth.

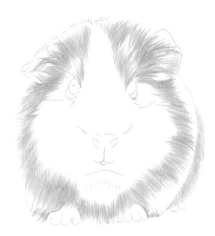

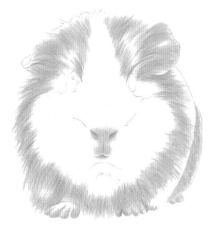

◄ **Step 3** I apply blush pink to the nose, and I indicate the nostrils and mouth with hot pink. I also use blush pink on the feet and areas of the ears.

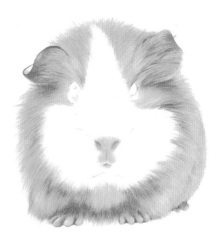

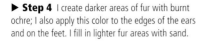**Step 4** I create darker areas of fur with burnt ochre; I also apply this color to the edges of the ears and on the feet. I fill in lighter fur areas with sand.

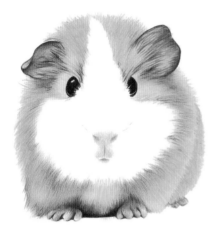

◄ **Step 5** I add dark shadows and fill in the eyes with espresso, leaving a highlight in each eye.

▶ **Step 6** I apply cool gray 30% and blue violet lake to create shadows in the white fur. I also use blue violet lake on the nostrils and crease below the nose. Finally, I deepen the outlines around the eyes and the shadows beneath the feet with black.

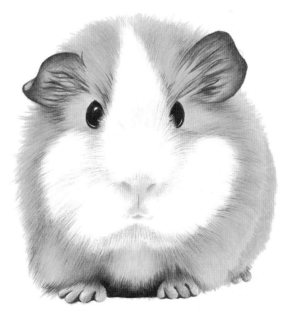

KITTEN

I often talk about using negative space in your drawings. When drawing cats this is especially helpful as their fur is typically short and composed of a multitude of different colors and values. In this project you can experiment with negative space by using dark colors to draw behind the lighter fur areas and suggesting the hairs rather than drawing them in directly. Since lighter colored pencils do not cover darker pencils very well, this technique is a useful and effective tool.

 Powder blue Warm grey 20% Spanish orange

| Limepeel | True blue | Powder blue | Henna | Warm grey 20% | Spanish orange | Burnt ochre | Black |

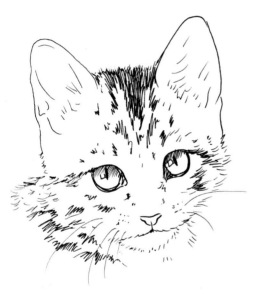

Step 1 To start, I transfer the drawing of the kitten onto a sheet of smooth, cotton drawing paper.

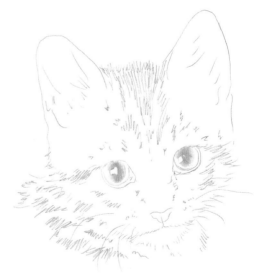

Step 2 I then begin the eyes and add a layer of limepeel around the pupils.

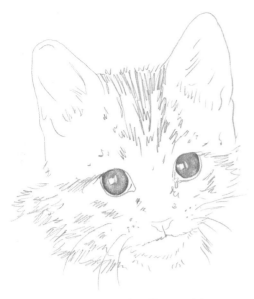

Step 3 Next I apply a layer of true blue around the outer edges of the eyes, leaving white highlights.

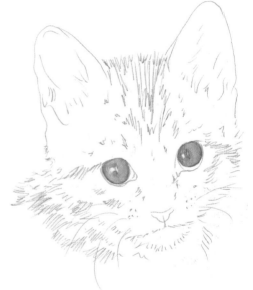

Step 4 To complete the eyes, I add powder blue with very heavy pressure. I go over the previous layers to blend them together, remembering to leave the highlights white.

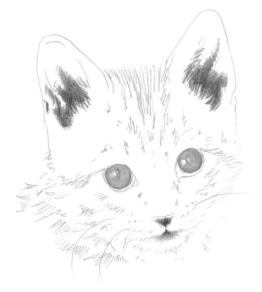

Step 5 For the ears, nose, and mouth I add henna. I apply the henna on the ears in a scratchy manner to create the look of fur. I use warm grey 20% to draw in white chin hairs and some hairs in the ears.

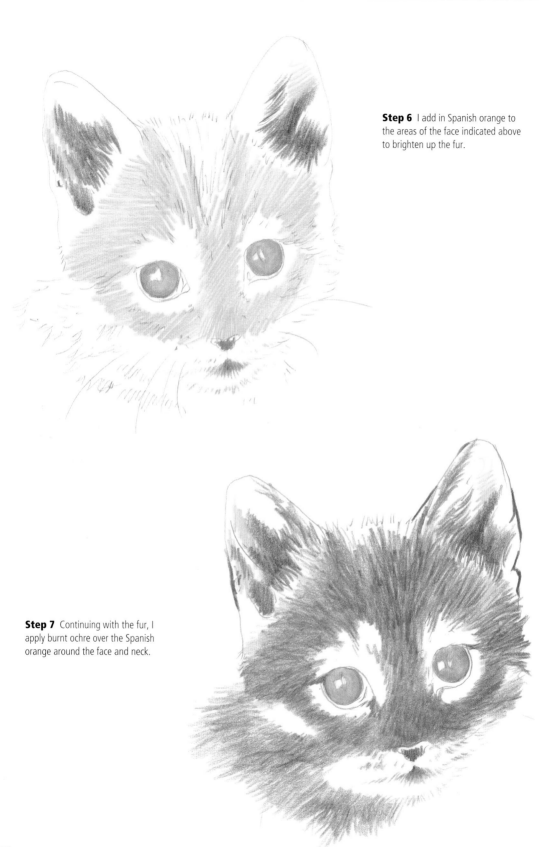

Step 6 I add in Spanish orange to the areas of the face indicated above to brighten up the fur.

Step 7 Continuing with the fur, I apply burnt ochre over the Spanish orange around the face and neck.

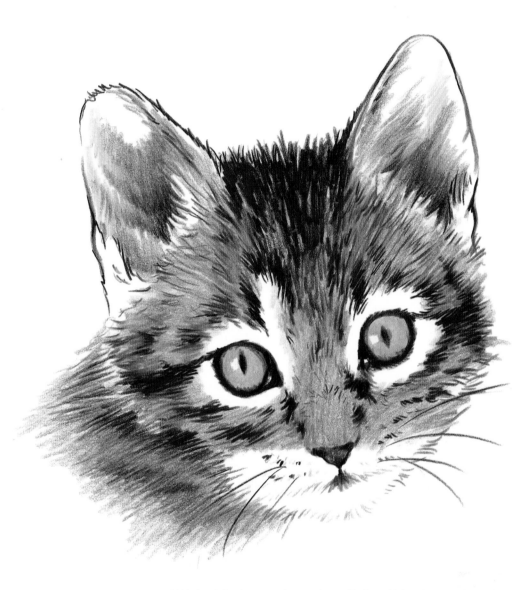

Step 8 Now I add black to define the eyes and nose. I also use black to add the stripes and other little details like whiskers.

COLORED PENCILS

This project is just plain fun! It is a great opportunity to use a multitude of different colors in one drawing. You are not limited to the colors I have chosen so feel free to experiment and explore your own color palette. In order to make your pencil barrels round, it is important to have a light side and an opposite shadow side. For the shadow side you'll simply apply your color with heavier pressure than on the light side. Another option for creating more complex shadows is to choose a slightly darker color and apply it to the shadow side of the pencil barrel; then place your final color over it for a deeper layered effect.

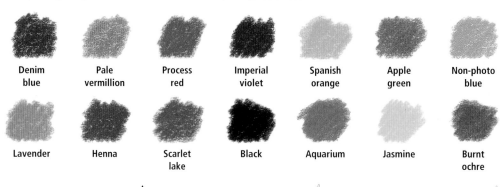

| Denim blue | Pale vermillion | Process red | Imperial violet | Spanish orange | Apple green | Non-photo blue |

| Lavender | Henna | Scarlet lake | Black | Aquarium | Jasmine | Burnt ochre |

Step 1 I lightly transfer the basic line drawing onto a sheet of smooth, acid-free drawing paper. It may help you to use a small ruler to keep your lines straight for this project.

Step 2 I use denim blue and pale vermilion to fill in the first two pencils. I apply heavier pressure on the left side of the barrels and lighter pressure on the right to indicate roundness.

Step 3 I use the same shading technique from step 2 for the next two pencils, this time using process red and imperial violet.

Step 4 I continue with Spanish orange and apple green to define the next set, remembering to keep my pressure varied.

Step 5 For the next two, I fill in non-photo blue and lavender.

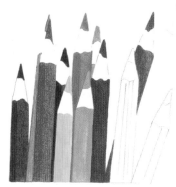

Step 6 Now I add the henna and scarlet lake pencils.

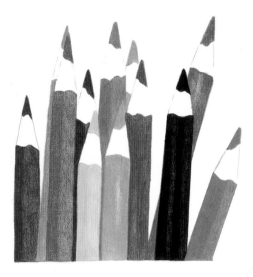

Step 7 Using black and aquamarine, I complete the line of pencils.

Step 8 In the final step, I place an even layer of jasmine on the sharpened end of each pencil to indicate the wood. I add burnt ochre on the left side of this area to create the shadow side and to make the wood appear round. Then I add black to shadow the barrels of the pencils in the back row.

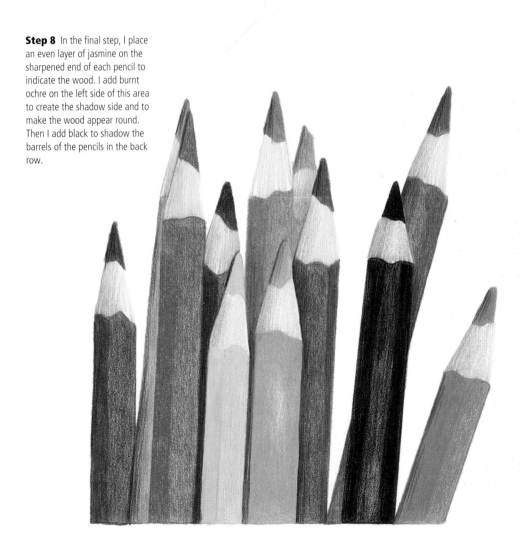

MANEKI NEKO (LUCKY CAT)

This is a drawing with lots of different shapes and colors to work with. There is no need to worry about drawing any fur on this cat, as it is ceramic and smooth. Soft, light layers of color will work best in this situation. One of the great elements of this project is the use of the metallic gold in the coin, claws, and tag. The metallics are applied in the same manner as the other pencil colors but are best applied on the top layer so their shiny characteristics can best be displayed.

| Pumpkin orange | Jasmine | Pink | Yellowed orange | Parrot green | Blush pink | Gold | Black | Blue slate |

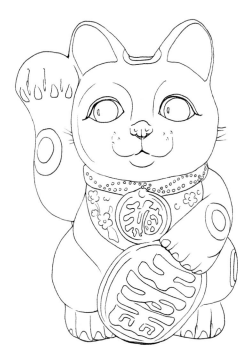

Step 1 I begin by transferring the line drawing to a clean sheet of drawing paper.

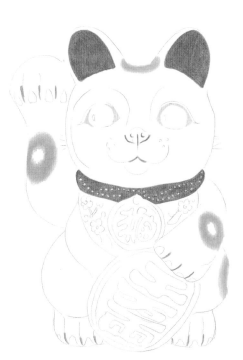

Step 2 Next I fill in the ears and collar of the cat with pumpkin orange. I use jasmine around the pupils of the eyes. To define the nails, mouth, and part of the nose, I apply pink. Yellowed-orange forms the outside of the spots.

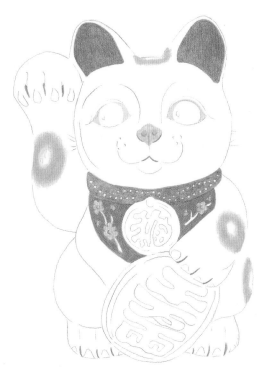

Step 3 I apply parrot green to the cat's bib, being careful to leave the flowers and branches white. I use blush pink to color in the flowers on the bib and to fill in and complete the nose.

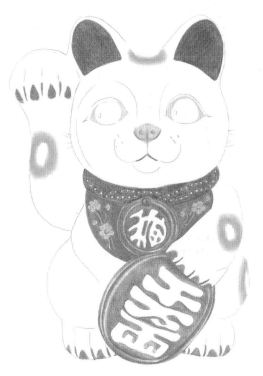

Step 4 I shape the claws, the branches in the bib, and the Lucky Cat's coins with gold.

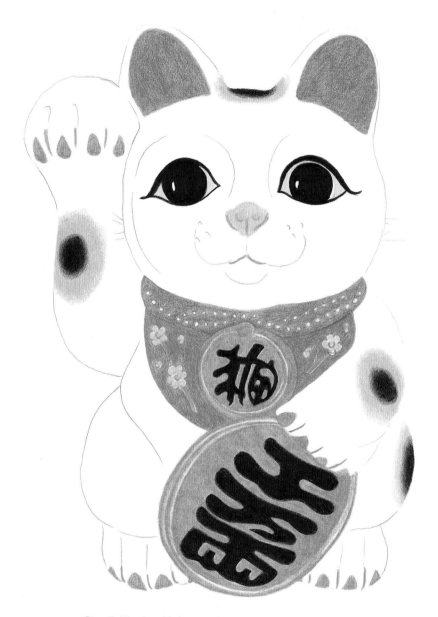

Step 5 I Now I use black to complete the spots, eyes, and lettering on the coins.

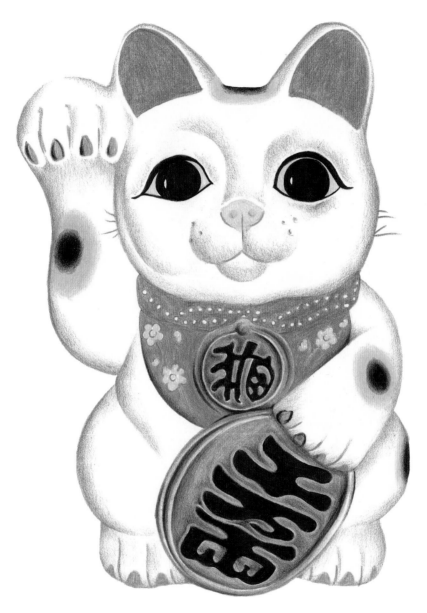

Step 6 In the final step, I shade with blue slate to define the cat's entire body. I use black to shade the coins, bib, and claws.

PUPPY

When drawing animals it is important to remember that you should not try to draw in every hair. It is better to look for areas of the fur that can be drawn in as a group. This puppy's fur has been broken down into light, medium, and dark grays to suggest the shiny coat and the general shape of the head. After these areas have been blocked in, you can go back and draw in some detailed hairs here and there. Using negative space, or drawing behind the hairs, is another great way to make animals appear furry without turning them into brillo pads!

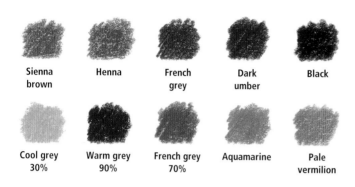

| Sienna brown | Henna | French grey | Dark umber | Black |

| Cool grey 30% | Warm grey 90% | French grey 70% | Aquamarine | Pale vermilion |

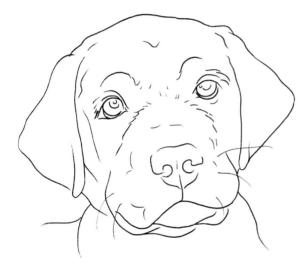

◄ Step 1 I start by transferring the line drawing of the puppy onto drawing paper.

▶ Step 2 I fill in the irises with sienna brown. Then I use henna to add some color around the eyes, nose, mouth, and cheeks.

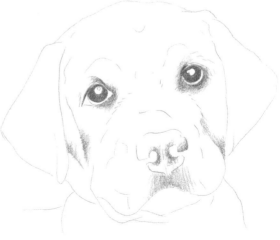

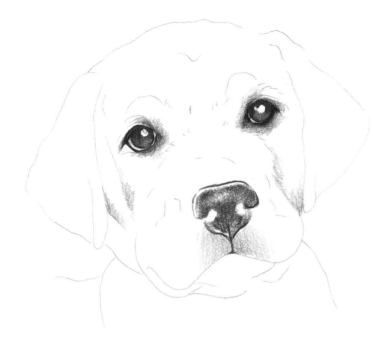

◄ **Step 3** Now I fill in the nose with French gray 90%, using heavier pressure for the outlines. Then I use dark umber to darken and outline the eyes.

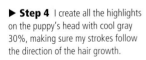 **Step 4** I create all the highlights on the puppy's head with cool gray 30%, making sure my strokes follow the direction of the hair growth.

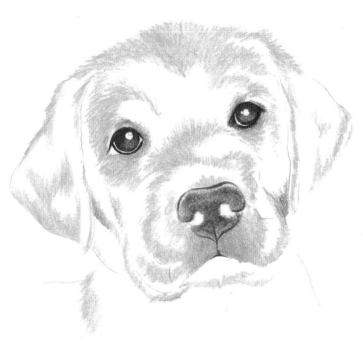

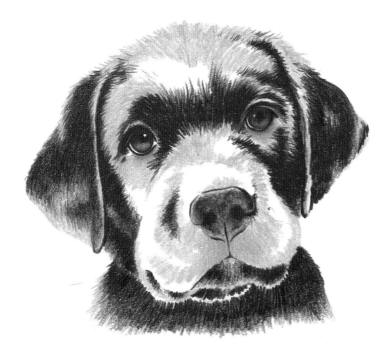

◄ **Step 5** Now I create the dark areas of fur with warm gray 90%. I use the same color to darken areas around the eyes and to fill in the nostrils.

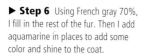

▶ **Step 6** Using French gray 70%, I fill in the rest of the fur. Then I add aquamarine in places to add some color and shine to the coat.

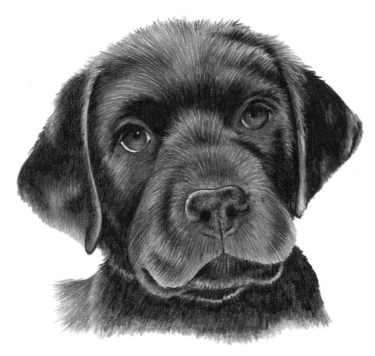

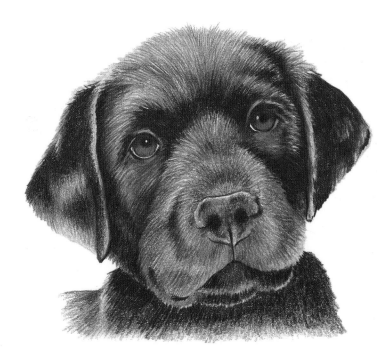

◀ **Step 7** Next I add a very light glaze of pale vermilion to the light part of the eyes and parts of the face to warm things up.

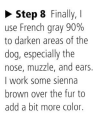

▶ **Step 8** Finally, I use French gray 90% to darken areas of the dog, especially the nose, muzzle, and ears. I work some sienna brown over the fur to add a bit more color.

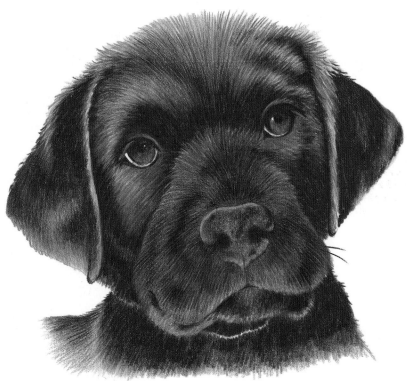

CLOSING WORDS

I have thoroughly enjoyed sharing with you my love of colored pencils; it is my hope that the tips and techniques in this book will give you the tools you need to continue to grow with this medium. Each drawing you create will lead to new discoveries and will build your artistic confidence. Experiment, explore, play, and practice. Soon you will develop your own style and passion for expressing yourself with colored pencils. Never be afraid to try—it's only paper!

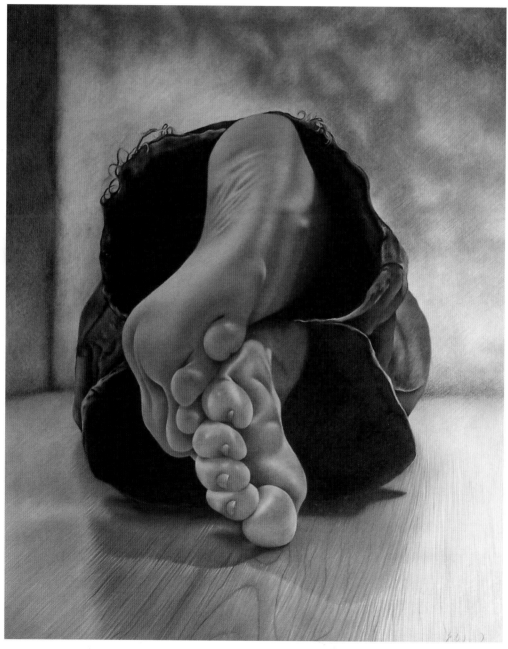

Sunday Morning